✦ Island Light ✦
Isles of Shoals

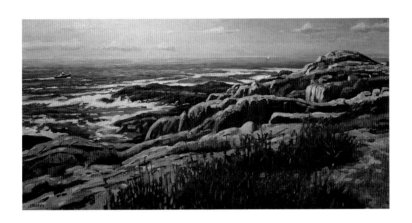

✦ Island Light ✦

Isles of Shoals

Introduction by Annie Boutelle
Excerpts from *Among the Isles of Shoals* by Celia Thaxter (1835–1894)

All contemporary paintings are courtesy of
The Banks Gallery, Portsmouth, New Hampshire.

Blue Tree
PORTSMOUTH

First published in the United States in 2006
by Blue Tree, LLC
P.O. Box 148
Portsmouth, NH 03802
www.thebluetree.com

37 10 1

Title page: Scott Moore
Out to Sea, oil on linen, 24 x 48 in.

Printed in Hong Kong

Library of Congress
Cataloging-in-Publication Data
2006926585

Isles of Shoals
Thaxter, Celia Laighton, 1835–1894
Excerpts from Among the Isles of Shoals/by Celia Thaxter
Includes index.

ISBN-10: 0-97113-218-6
ISBN-13: 978-0-9711321-8-4

For customer service and orders:
Local 603.436.0831
Toll-Free 1.866.852.5357
Email sales@thebluetree.com

Blue Tree

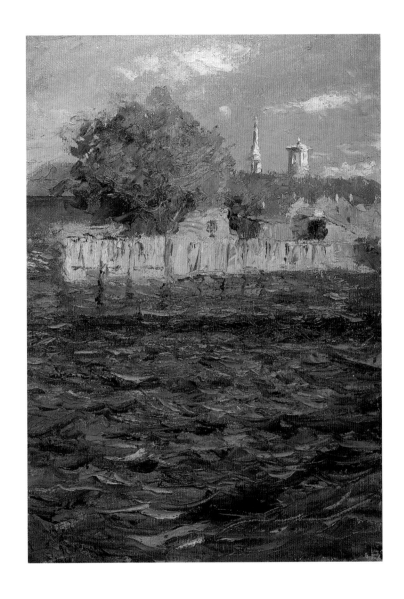

Addison Thomas Millar (1860–1913), *Portsmouth*, oil on board, 14 x 19 ¾ in.
The collection of Douglas and Karin Nelson

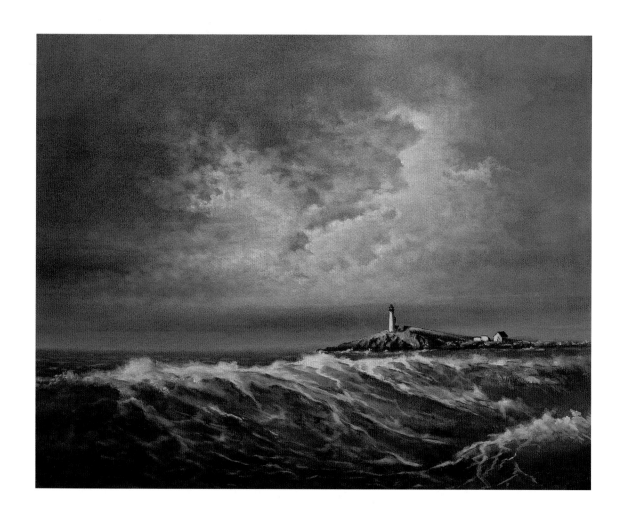

Ron Brown, *White Island Light*, oil on canvas, 24 x 30 in.

White Island Light

I saw it first in 1974, when my husband, Will, agreed to be doctor on Star Island for one of the summer conferences. Neither of us had any notion what the Shoals were like, and I remember being on the boat, and suddenly there were the islands, looming out of the fog, mysterious and stern, the wooden structures on them seeming strangely temporary, and I remember the sense of a deep silence underpinning the surge of the sea and the clamor of the gulls.

I was drawn to the Shoals because they reminded me, in their starkness and severity, of the west coast of Scotland, where I grew up. This was no prettified landscape. This was something elemental: granite and salt water and space.

From our rocking chairs at the west end of the Oceanic porch, we looked out at White Island and the wavering line of shore far behind it. While we knew nothing then about Celia Thaxter or the hardy Laighton family, White Island was clearly iconic: that sharp bluff ("The Head"), the courage of that gravity-defying tower, the slanting line of the covered passageway, the house itself crouching low. Our eyes would drift off to other items—laundry on the line, a retreating wave, a sailboat almost motionless—but would return again and again to the lighthouse. One cannot help but look at it. And it cannot help itself: it can only dominate.

Later I would read, in Thaxter's *Among the Isles of Shoals*, of the red sky that blazed in the background as the Laighton family approached White Island for the first time in October 1839. Goats peered down at them from the dark rocks. Thaxter's prose makes vivid the details of their lives: the thick ice that coated passing boats and covered every window; the walnuts skittering down the stairs "in briny foam"; the frenzied shrieking of the winter gale; the old man rowing across from Gosport "so lean and brown and ancient, he might have been Methuselah, for no one knew how long he had lived on this rolling planet"; the crescent-shaped marigold seeds planted in thin soil.

And later still, I would read, in David Park Curry's *Childe Hassam: An Island Garden Revisited*, of how Thaxter entranced the young artist who substituted for her drawing teacher in Boston, how she renamed him by encouraging him to follow Mr.Kipling's lead, and drop his given name (Frederick) and use instead his middle name (Childe), and how she tempted him out to the Shoals, where he took as subject matter, for his first series of Shoals watercolors, the lighthouse itself. Lighthouse, 1886, is delicate and lovely, each turn of the tower something precious and vulnerable, each shadow a soft violet.

And even later, I would give a talk, at the Smith College Museum of Art, on the subject of Childe Hassam's *White Island Light, Isles of Shoals at Sundown*. The painting is both landscape and memorial: a tribute to Hassam's friend, painted in 1899 when he returned to the Shoals five long years after her death. In no other painting, after that first watercolor series, does Hassam focus so intently on the lighthouse and its island, Thaxter's childhood home. All the oddities—the long title, the

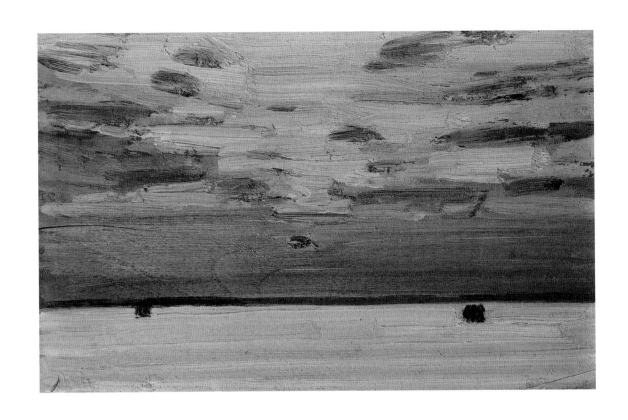

Childe Hassam (1859–1935), *Appledore Sunrise,* oil on cigar box lid, 5 ½ x 8 ⅜ in.
Private collection

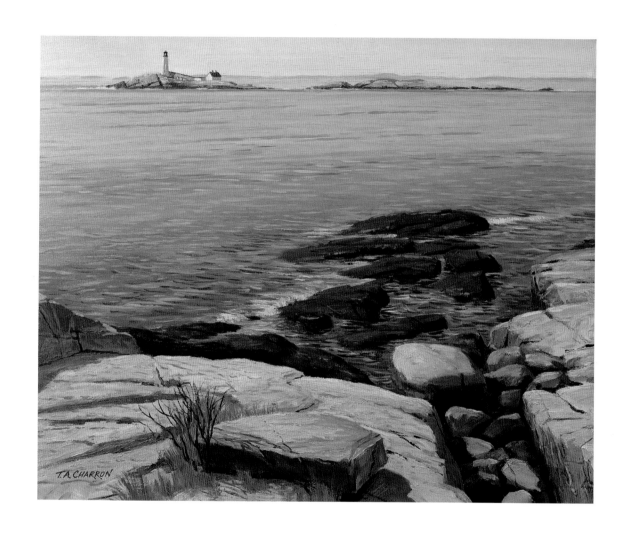

T. A. Charron, *White Island Light*, oil on panel, 16 x 20 in.

tilting horizon line, the mirror-relationship between lighthouse and gorge—point to his grief and to his desire to honor all that she had taught him about life and art.

Out of this chain of events came *Becoming Bone: Poems on the Life of Celia Thaxter.* One of the deep delights of writing the poems was returning in imagination to White Island Light: "my father's tower, unmoved, / unmoving, on a disk of tilted sea." For several years, I almost felt as if I lived on that "storm-swept bit of rock," as Oscar Laighton described it. And I would look up from my computer in surprise, to discover myself so far inland.

May you find delight too, in this collection of images of Isles of Shoals. May White Island Light continue to blaze forth, keeping ships from harm. May you feel the breeze (and not the gale) on your cheek. May you shade your eyes against the dazzle. And may you hear, under the surge of the sea and the clamor of the gulls, that huge untouchable silence.

—Annie Boutelle
Smith College
Northampton, Massachusetts
April 2006

✦ ISLAND LIGHT ✦

Isles of Shoals

Excerpts from
Among the Isles of Shoals
by Celia Thaxter (1835–1894)

A WORD ABOUT THE ORIGIN OF THIS NAME, 'Isles of Shoals.' They are supposed to have been so called, not because the ragged reefs run out beneath the water in all directions, ready to wreck and destroy, but because of the 'shoaling,' or 'schooling,' of fish about them, which, in the mackerel and herring seasons, is remarkable. As you approach they separate, and show each its own peculiar characteristics, and you perceive that there are six islands if the tide is low; but if it is high, there are eight, and would be nine, but that a breakwater connects two of them. Appledore, called for many years Hog Island, from its rude resemblance to a hog's back rising from the water, when seen from out at sea, is the largest and most regular in shape. From afar, it looks smoothly rounded, like a gradually sloping elevation, the greatest height of which is only seventy-five feet above high-water mark. A little valley in which are situated the buildings belonging to the house of entertainment, which is the only habitation, divides its four hundred acres into two unequal portions.

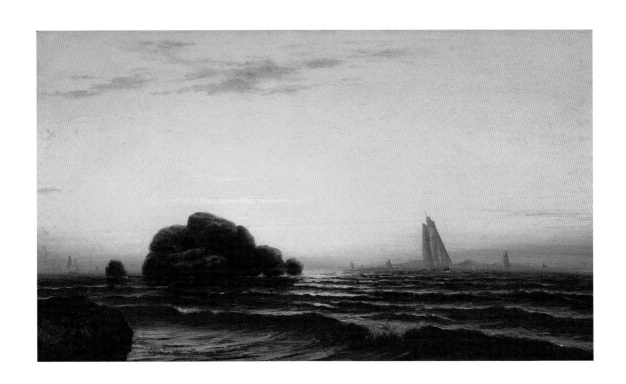

William Frederick De Haas (1830–1880), *From Appledore Island,* oil on board, 8 x 14 in.
Courtesy of Hawthorne Fine Art

Charles Herbert Woodbury (1864–1940), *Color Note*, oil on board, 8 x 10 in.
The collection of Dr. and Mrs. William F. Wieting

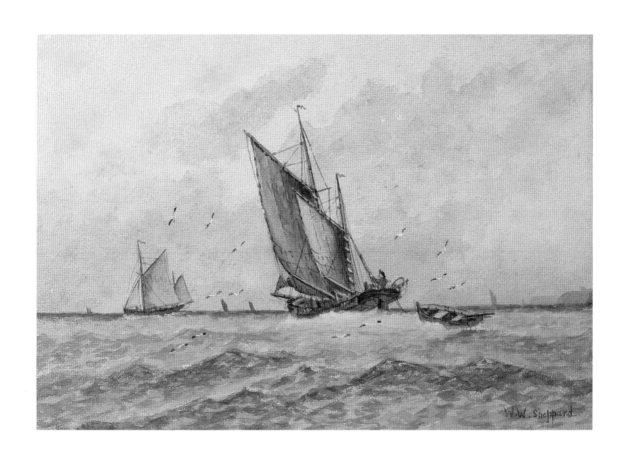

Warren W. Sheppard (1858–1937), *Off the Coast*, watercolor, 9 ½ x 13 ½ in.
The collection of Douglas and Karin Nelson

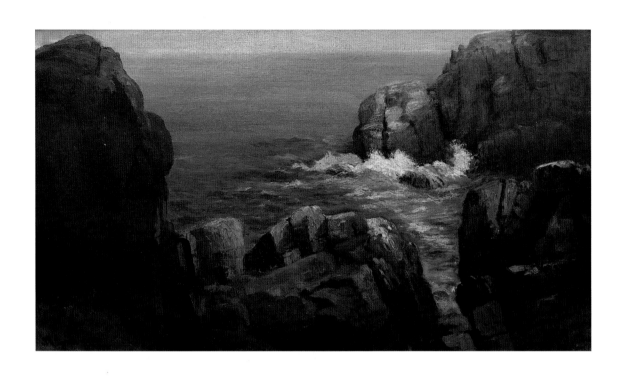

John Appleton Brown (1844–1902), *Appeldore*, oil on canvas, 16 x 28 in.
The collection of Douglas and Karin Nelson

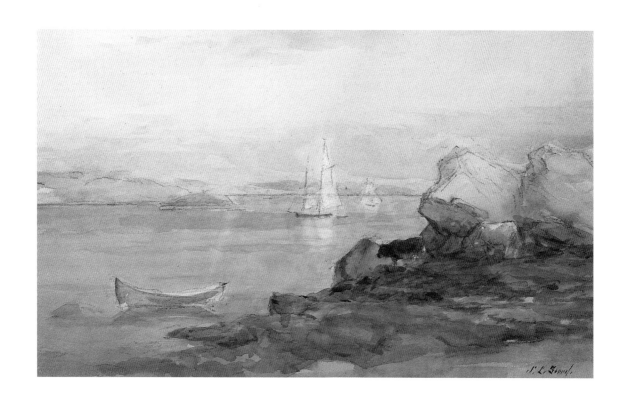

Samuel Lancaster Gerry (1813–1891), *Celia Thaxter's Cows*, watercolor, 7 ½ x 12 ½ in.
The collection of Douglas and Karin Nelson

NEXT, ALMOST WITHIN A STONE'S THROW, is Haley's Island, or 'Smuttynose,' so christened by passing sailors, with a grim sense of humor, from a long black point of rock stretching out to the southeast, upon which many a ship has laid her bones. This island is low and flat, and contains a greater depth of soil than the others. At low tide, Cedar and Malaga are both connected with it—the latter permanently by a breakwater—the whole comprising about one hundred acres. Star Island contains one hundred and fifty acres, and lies a quarter of a mile southwest of Smuttynose. Toward its northern end are clustered the houses of the little village of Gosport, with a tiny church crowning the highest rock. Not quite a mile southwest from Star, White Island lifts a lighthouse for a warning. This is the most picturesque of the group, and forms, with Seavey's Island, at low water, a double island, with an area of some twenty acres.

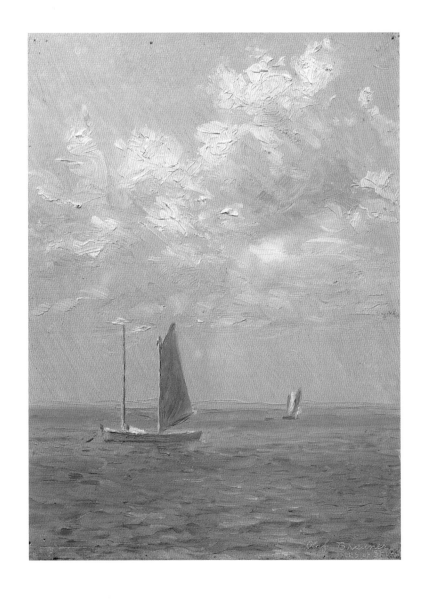

Olaf Martinius Brauner (1869–1947), *Sailing off the Isles of Shoals*, oil on canvas, 8 x 6 in.
Private collection

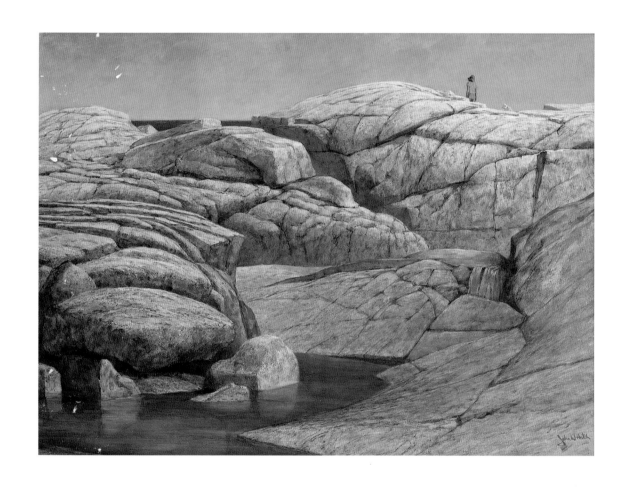

John Woodsum Hatch (1920–1998), *Jumping off Rock*, acrylic and egg tempera on panel, 36 x 48 in.
The collection of Morgan Stanley, Portsmouth, New Hampshire

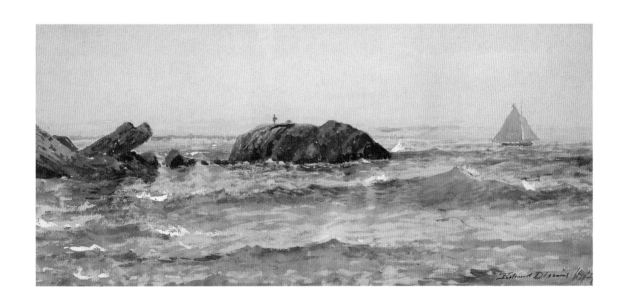

Edmond Darch Lewis (1835–1910), *Along the Coast*, watercolor, 9 ¼ x 19 ¾ in.
The collection of Dr. and Mrs. William F. Wieting

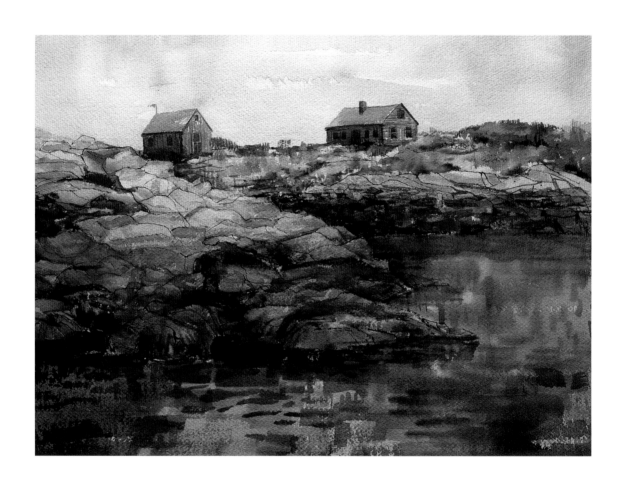

Herbert S. Lourie (1823–1981), *Malaga and Smuttynose*, watercolor, 15 ⅛ x 20 ⅝ in.
The collection of the Herbert S. Lourie Estate

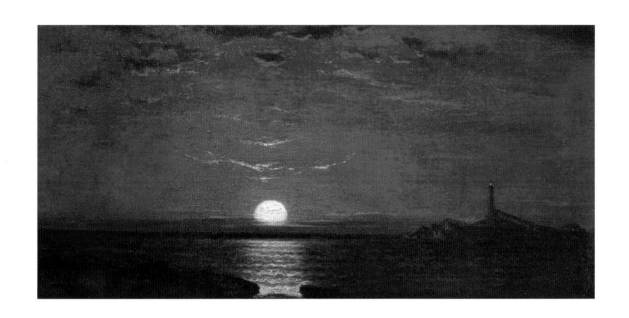

John Christopher Miles (1837–1911), *Moon Rise at the Isles of Shoals,* oil on canvas, 15 x 30 in.
The collection of Douglas and Karin Nelson

MOST WESTERLY LIES LONDONER'S, AN irregular rock with a bit of beach, upon which all the shells about the cluster seem to be thrown. Two miles northeast from Appledore, Duck Island thrusts out its lurking ledges on all sides beneath the water, one of them running half a mile to the northwest. This is the most dangerous of the islands, and being the most remote, is the only one visited to any great degree by the shy sea-fowl that are nearly banished by civilization. Yet even now, at low tide, those long black ledges are often whitened by the dazzling plumage of gulls whose exquisite and stainless purity rivals the new-fallen snow. The ledges run toward the west and north; but at the east and south the shore is bolder, and Shag and Mingo Rocks, where, during or after storms, the breaks with magnificent effect, lie isolated by a narrow channel from the main granite fragment. A very round rock west of Londoner's, perversely call 'Square,' and Anderson's Rock, off the southeast end of Smuttynose, complete the catalogue.

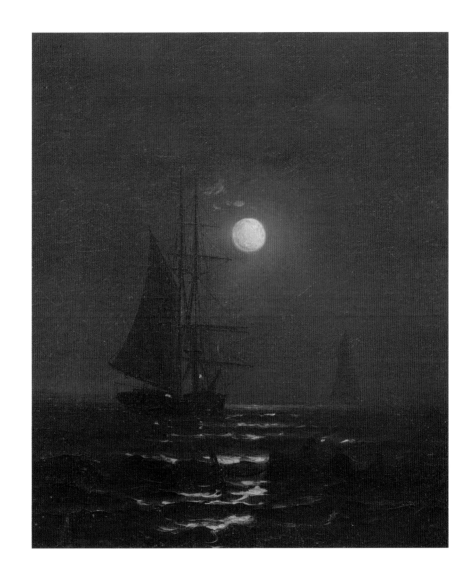

Warren W. Sheppard (1858–1937), *Sailing by Moonlight,* oil on canvas, 12 x 10 in.
The collection of Dr. and Mrs. William F. Wieting

SAILING OUT FROM PORTSMOUTH HARBOR with a fair wind from the northwest, the Isles of Shoals lie straight before you, nine miles away—ill-defined and cloudy shapes, faintly discernible in the distance.

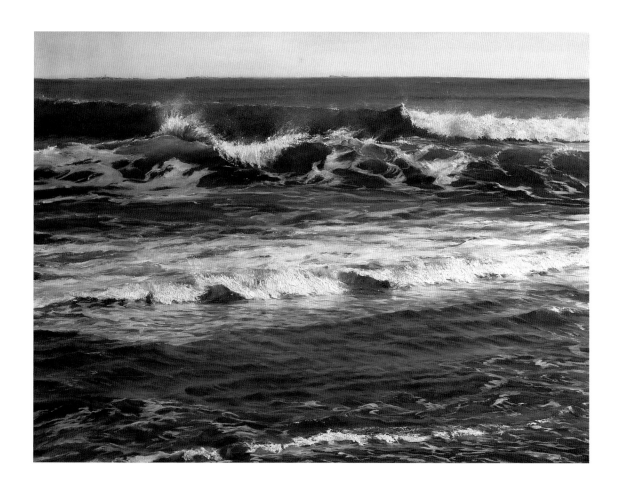

Sally Ladd-Cole, *View from Wallace Sands*, oil on canvas, 30 x 40 in.

SWEPT BY EVERY WIND THAT BLOWS, AND beaten by the bitter brine for unknown ages, well may the Isles of Shoals be barren, bleak, and bare. At first sight nothing can be more rough and inhospitable than they appear. The incessant influences of wind and sun, rain, snow, frost, and spray, have so bleached the tops of the rocks, that they look hoary as if with age, though in the summer-time a gracious greenness of vegetation breaks here and there the stern outlines, and softens somewhat their rugged aspect. Yet so forbidding are their shores, it seems scarcely worth while to land upon them—mere heaps of tumbling granite in the wide and lonely sea—when all the smiling, 'sapphire-spangled marriage-ring of the land' lies ready to woo the voyager back again, and welcome his returning prow with pleasant sights and sounds and scents that the wild wastes of water never know.

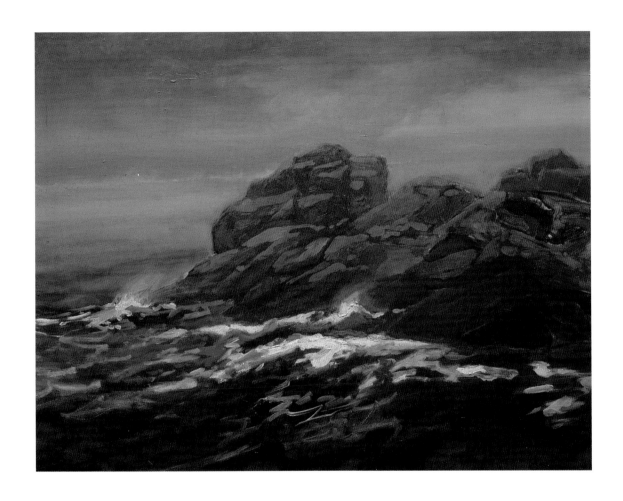

Tom Glover, *Sea Mist*, oil on panel, 14 x 18 in.

BUT TO THE HUMAN CREATURE WHO HAS EYES that will see and ears that will hear, nature appeals with such a novel charm, that the luxurious beauty of the land is half forgotten before one is aware. Its sweet gardens, full of color and perfume, its rich woods and softly swelling hills, its placid waters, and fields and flowery meadows, are no longer dear and desirable; for the wonderful sound of the sea dulls the memory of all past impressions, and seems to fulfil and satisfy all present needs.

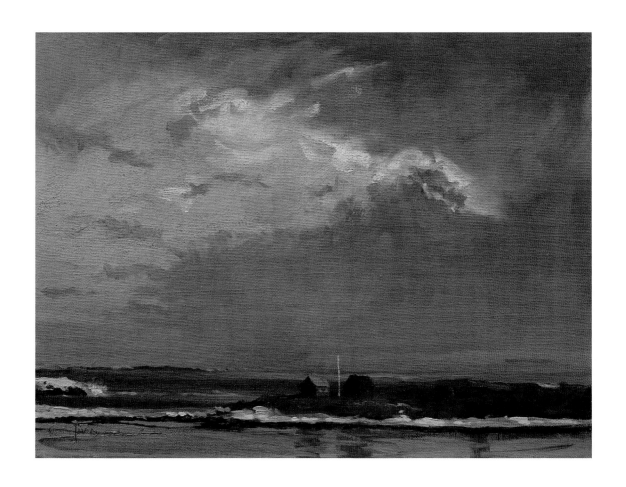

Louis Guarnaccia, *Breaking Light*, oil on linen, 8 x 10 in.

LANDING FOR THE FIRST TIME, THE STRANGER is struck only by the sadness of the place—the vast loneliness; for there are not even trees to whisper with familiar voices—nothing but sky and sea and rocks. But the very wildness and desolation reveal a strange beauty to him. Let him wait till evening comes, 'with sunset purple soothing all the waste,' and he will find himself slowly succumbing to the subtle charm of that sea atmosphere.

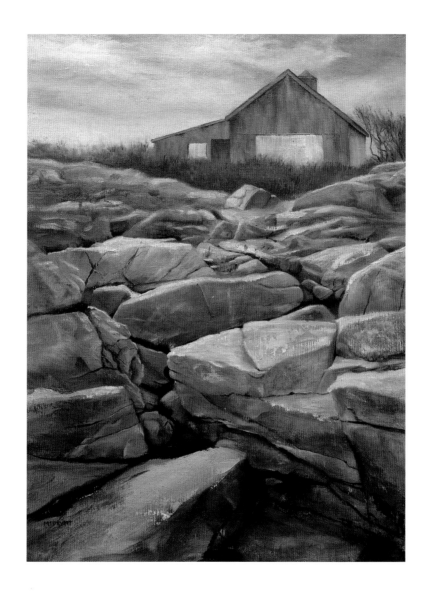

Barrett McDevitt, *Rocks on Star Island*, oil on canvas laid on board, 12 x 16 in.

ALL THINGS ARE SPECKLESS AND SPOTLESS; there is no dust, no noise, nothing but peace in the sweet air and on the quiet sea. The day goes on; the rose changes to mellow gold, the gold to clear, white daylight, and the sea is sparkling again.

Katherine Doyle, *Islands,* mixed media on paper, 26 x 20 in.

AT LOW WATER THE SHORES ARE MUCH more forbidding than at high tide, for a broad band of dark sea-weed girdles each island, and gives a sullen aspect to the whole group. But in calm days, when the moon is full and the tides are so low that it sometimes seems as if the sea were being drained away on purpose to show to eager eyes what lies beneath the lowest ebb, banks of golden-green and brown moss thickly clustered on the moist ledges are exposed, and the water is cut by the ruffled edges of the kelps that grow in brown and shining forests on every side. At sunrise or sunset the effect of the long rays slanting across these masses of rich color is very beautiful. But at high tide the shores are most charming; every little cove and inlet is filled with the music of the waves, and their life, light, color, and sparkle.

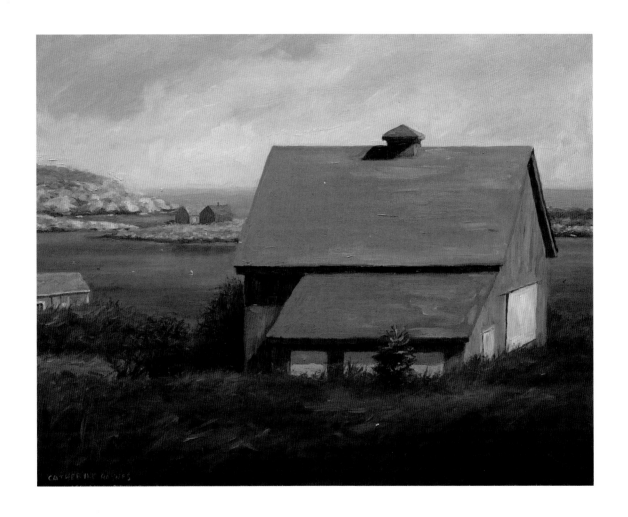

Catherine Raynes, *Star Island Barn,* oil on panel, 11 x 14 in.

WITHIN THE LOVELY LIMITS OF SUMMER it is beautiful to live almost anywhere; most beautiful where the ocean meets the land; and here particularly, where all the varying splendor of the sea encompasses the place, and the ceaseless changing of the tides brings continual refreshment into the life of every day. But summer is late and slow to come; and long after the mainland has begun to bloom and smile beneath the influence of spring, the bitter northwest winds still sweep the cold, green water about these rocks, and tear its surface into long and glittering waves from morning till night, and from night till morning, through many weeks. No leaf breaks the frozen soil, and no bud swells on the shaggy bushes that clothe the slopes. But if summer is a laggard in her coming, she makes up for it by the loveliness of her lingering into autumn; for when the pride of trees and flowers is despoiled by frost on shore, the little gardens here are glowing at their brightest, and day after day of mellow splendor drops like a benediction from the hand of God.

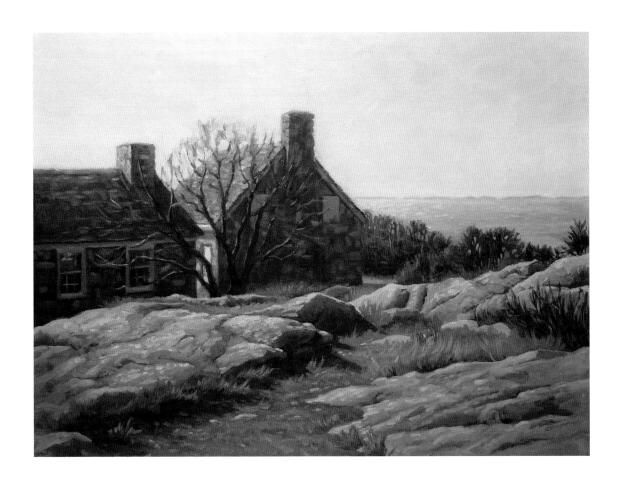

Lisa Jelleme-Miller, *Stone Cottages Star Island*, oil on board, 18 x 24 in.

AFTER THIS THERE SOON COME DAYS WHEN TO be alive is quite enough joy—days when it is bliss only to watch and feel how 'God renews His ancient rapture,'—days when the sea lies, colored like a turquoise, blue and still, and from the south a band of warm, gray-purple haze steals down on the horizon like an encircling arm about the happy world. The lightest film encroaches upon the sea, only made perceptible by the shimmering of far-off sails.

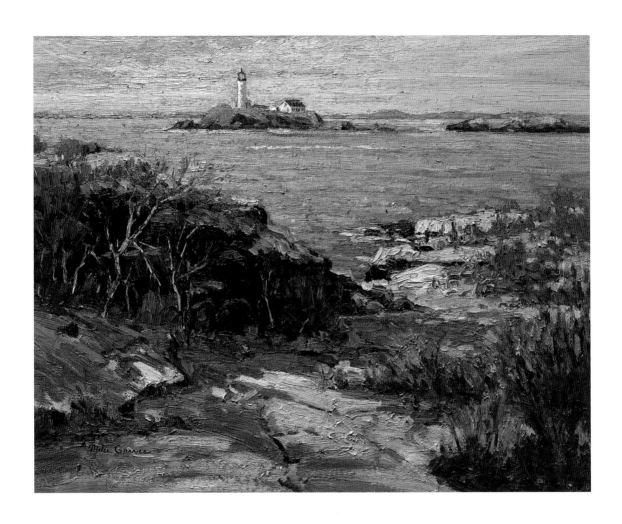

Mike Graves, *White Island Light*, oil on linen, 16 x 20 in.

AT THE WATER'S EDGE ONE FINDS THE LONG ledges covered with barnacles, and from each rough shell a tiny, brown, filmy hand is thrust out, opening and shutting in gladness beneath the coming tide, feeling the freshness of the flowing water. The shore teems with life in manifold forms.

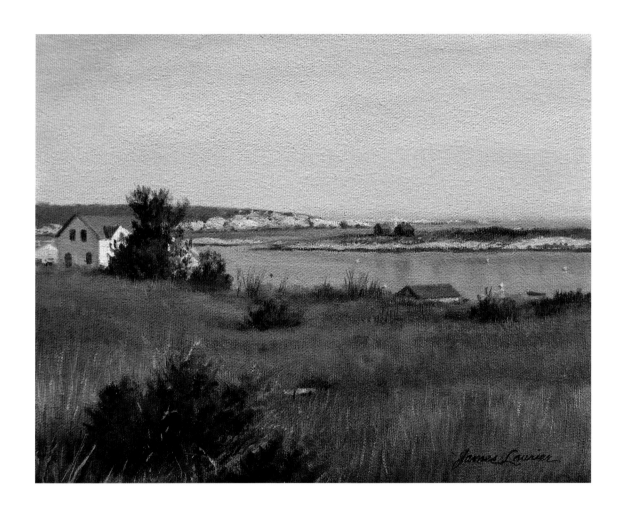

James Laurier, *Across Gosport Harbor,* oil on canvas, 8 x 10 in.

THE SEA IS DEEP INDIGO, WHITENED WITH flashing waves all over the surface; the sky is speckless; no cloud passes across it the whole day long; and the sun sets red and clear, without any abatement of the wind. The spray flying on the western shore for a moment is rosy as the sinking sun shines through, but for a moment only—and again there is nothing but the ghastly whiteness of the salt-water ice, the cold gray rock, the sullen, foaming brine, the unrelenting heavens, and the sharp wind cutting like a knife. All night long it roars beneath the hollow sky—roars still at sunrise.

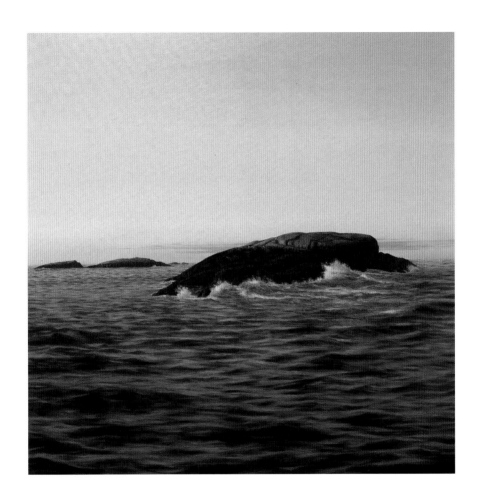

Sean Beavers, *Over Looking Eastern Rocks,* oil on canvas laid on panel, 20 x 20 in.

MANY A SUMMER MORNING HAVE I CREPT out of the still house before any one was awake, and, wrapping myself closely from the chill wind of dawn, climbed to the top of the high cliff called the Head to watch the sunrise. Pale grew the lighthouse flame before the broadening day as, nestled in a crevice at the cliff's edge, I watched the shadows draw away and morning break. Facing the east and south, with all the Atlantic before me, what happiness was mine as the deepening rose-color flushed the delicate cloudflocks that dappled the sky, where the gulls soared, rosy too, while the calm sea blushed beneath.

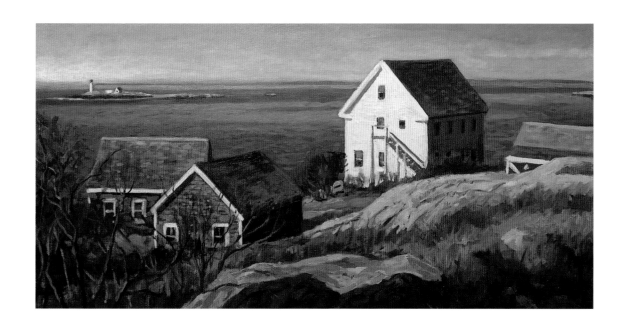

Scott Moore, *White Island Light from Star Island*, oil on linen, 18 x 36 in.

STAR ISLAND SEEMED A PLACE OF GREATER safety; and probably the greater advantages of landing and the convenience of a wide cove at the entrance of the village, with a little harbor wherein the fishing-craft might anchor with some security, were also inducements. William Pepperell, a native of Cornwall, England, emigrated to the place in the year 1676, and lived there upwards of twenty years, and carried on a large fishery. 'He was the father of Sir William Pepperell, the most famous man Maine ever produced.' For more than a century previous to the Revolutionary War there were at the Shoals from three to six hundred inhabitants, and the little settlement flourished steadily.

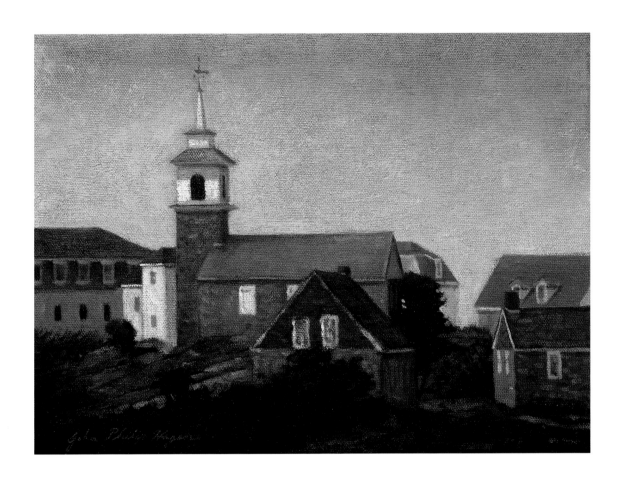

John Philip Hagen, *Star Island*, oil on canvas, 9 x 12 in.

THE RAINY DAYS IN MAY AT THE ISLES OF Shoals have seemed to me more lovely than the sunshine in Paradise could be, so charming it was to walk in the warm showers over our island, and note all the mosses and lichens drenched and bright with the moisture, thick, sweet buds on the bayberry bushes, rich green leaves unfolding here and there among the tangled vines, and bright anemones growing up between. The lovely eye-bright glimmers everywhere. The rain, if it continues for several days, bleaches the sea-weed about the shores to a lighter and more golden brown, the sea is gray, and the sky lowers; but all these neutral tints are gentle and refreshing.

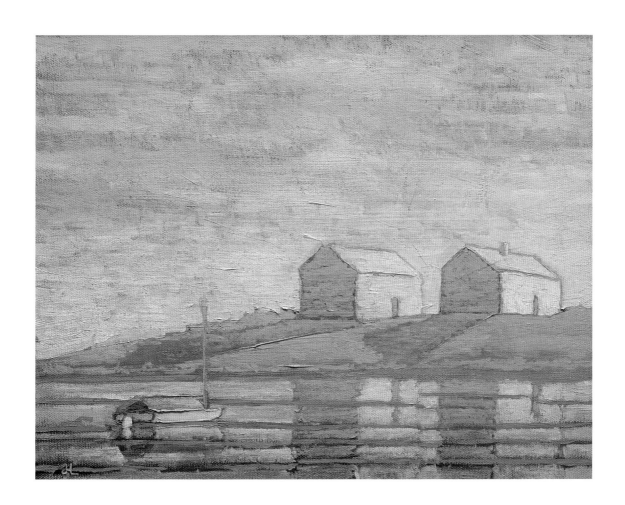

Jamie LaFleur, *Sunrise at Smuttynose*, oil on canvas, 11 x 14 in.

IT REQUIRES A STRONG EFFORT TO EMERGE FROM this lotus-eating state of mind. O, lovely it is, on sunny afternoons to sit high up in a crevice of the rock and look down on the living magnificence of breakers such as made music about us after the Minot's Ledge storm—to watch them gather, one after another, which makes the solid earth tremble, and you, clinging to the moist rock, feel like a little cockleshell!

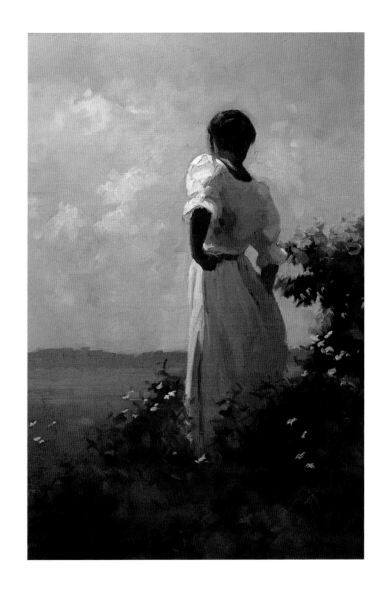

Dennis Perrin, *At the point*, oil on linen, 36 x 24 in.

How lovely then the gentle neutral tints of tawny intervals of dead grass and brown bushes and varying stone appear, set in the living sea! There is hardly a square foot of the bare rock that isn't precious for its soft coloring; and freshly beautiful are the uncovered lichens that with patient fingering have ornamented the rough surfaces with their wonderful embroideries. They flourish with the greatest vigor by the sea; whole houses at Star used to be covered with the orange-colored variety.

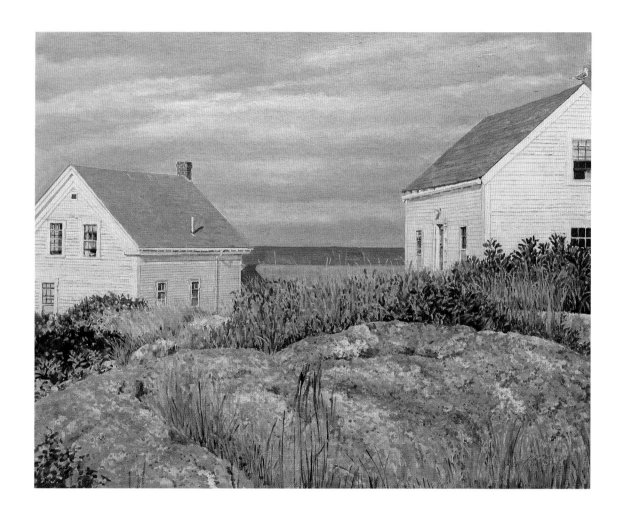

Dahl Taylor, *Star Island*, acrylic on canvas, 16 x 20 in.

IF YOU ARE OUT OF THE REACH OF THE HEAVY fall of spray, the fine salt mist will still stream about you, and salute your cheek with the healthful freshness of the brine, make your hair damp, and encrust your eyebrows with salt. While you sit watching the shifting splendor, uprises at once a higher cloud than usual; and across it springs a sudden rainbow, like a beautiful thought beyond the reach of human expression.

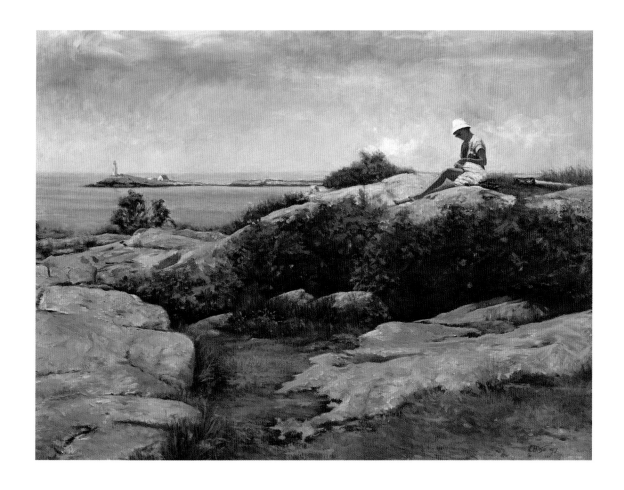

Tom Chase, *Knitting at the Isles of Shoals*, oil on linen, 24 x 32 in.

THE SKY DEEPENS ITS BLUE; BENEATH IT THE brilliant sea glows into violet, and flashes into splendid purple where the 'tide-rip,' or eddying winds, make long streaks across its surface (poets are not wrong who talk of 'purple seas,') the air is clear and sparkling, the lovely summer haze withdraws, all things take a crisp and tender outline, and the cry of the curlew and the plover is doubly sweet through the pure, cool air. Then sunsets burn in clear and tranquil skies, or flame in piled magnificence of clouds.

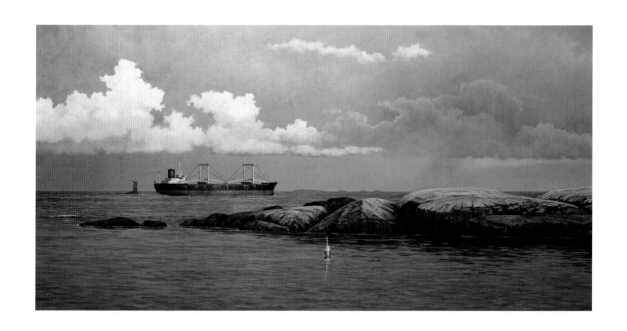

Simon Harling, *Evening Light from Fort Stark*, oil on canvas, 24 x 48 in.

THE SEA IS ROSY, AND THE SKY; THE LINE OF land is radiant; the scattered sails glow with the delicious color that touches so tenderly the bare, bleak rocks. These are lovelier than sky or sea or distant sails, or graceful gulls' wings reddened with the dawn; nothing takes color so beautifully as the bleached granite; the shadows are delicate, and the fine, hard outlines are glorified and softened beneath the fresh first blush of sunrise.

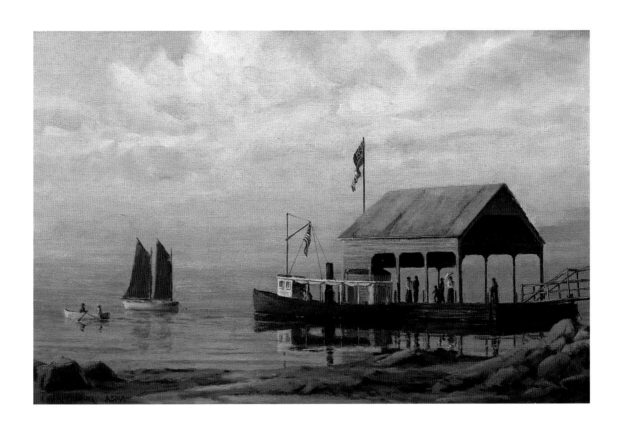

John Morrison, *Appledore Island*, oil on linen, 12 x 18 in.

Upon Appledore and the little islets undevastated by civilization these tiny coves are the most delightful places in the world, lovely with their fringe of weeds, thistles, and mullein-stalks drawn clearly against the sky at the upper edge of the slope, and below, their mosaic of stone and shell and sea-wrack, tangles of kelp and driftwood—a mass of warm neutral tints—with brown, green, and crimson mosses, and a few golden snail-shells lying on the many-tinted gravel, where the indolent ripples lapse in delicious murmurs.

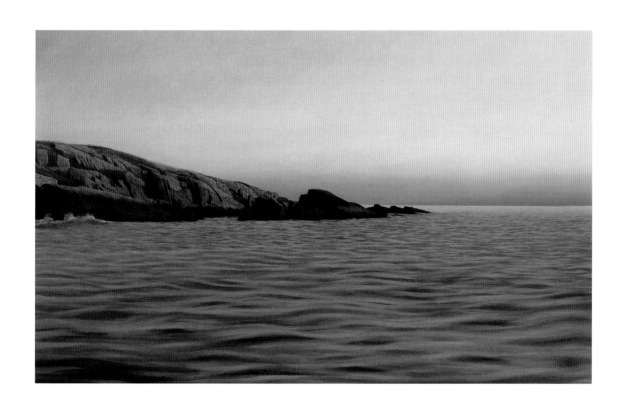

Sydney Sparrow, *Appledore's Dusk*, oil on canvas laid on panel, 16 x 24 in.

I<small>T'S WAS WONDERFUL TO WAKE ON SOME</small> midsummer morning and find the sea gray-green, like translucent chrysoprase, and the somewhat stormy sunrise painting the sails bright flame-color as they flew before the warm, wild wind that blew strongly from the south. At night, sometimes, in a glory of moonlight, a vessel passed close in with all sail set, and only just air enough to fill the canvas, enough murmur from the full tide to drown the sound of her movement—a beautiful ghost stealing softly by, and passing in mysterious light beyond the glimmering headland out of sight.

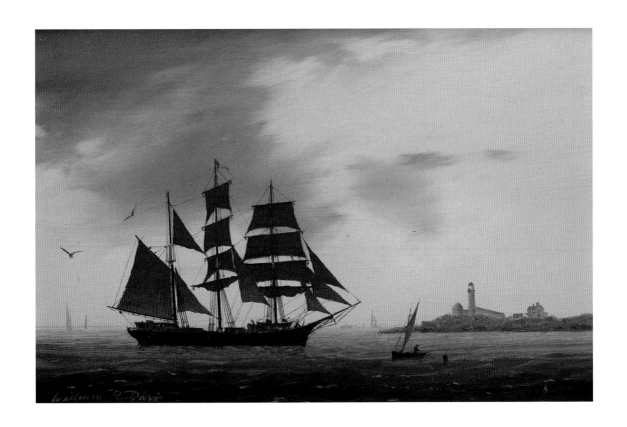

William R. Davis, *Dusk at Isles of Shoals*, oil on panel, 8 x 12 in.

SEVERAL SNOWY OWLS HAUNT THE ISLANDS the whole winter long. I have never heard them cry like other owls; when disturbed or angry, they make a sound like a watchman's rattle, very loud and harsh, or they whistle with intense shrillness, like a human being. Their habitual silence adds to their ghostliness; and when at noonday they sit, high up, snow-white above the snow drifts, blinking their pale yellow eyes in the sun, they are weird indeed. One night in March I saw one perched upon a rock between me and the 'last remains of sunset dimly burning' in the west, his curious outline drawn black against the redness of the sky, his large head bent forward, and the whole aspect meditative and most human in its expression. I longed to go out and sit beside him and talk to him in the twilight, to ask him the story of his life, or, if he would have permitted it, to watch him without a word. The plumage of this creature is wonderfully beautiful—white, with scattered spots like little flecks of tawny cloud—and his black beak and talons are powerful and sharp as iron; he might literally grapple his friend, or his enemy, with hooks of steel. As he is clothed in a mass of down, his outlines are so soft that he is like an enormous snowflake while flying; and he is a sight worth seeing when he stretches wide his broad wings, and sweeps down on his prey, silent and swift, with an unerring aim, and bears it off to the highest rock he can find, to devour it.

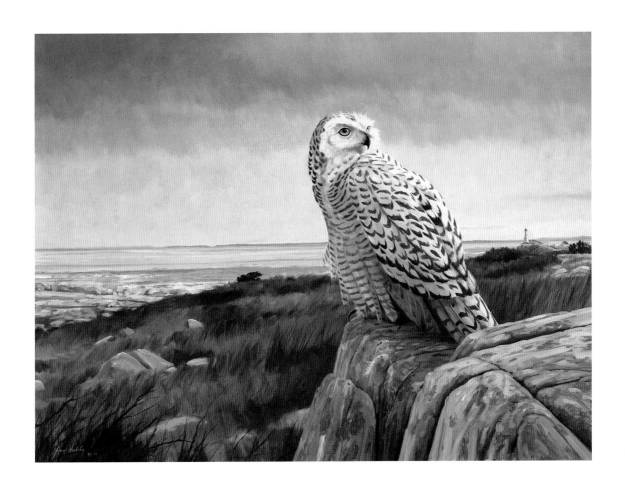

Grant Hacking, *Snowy Owl, Isles of Shoals*, oil on canvas, 30 x 40 in.

WHO SHALL DESCRIBE THAT WONDERFUL noise of the sea among the rocks, to me the most suggestive of all the sounds in nature? Each island, every isolated rock, has its own peculiar rote, and ears made delicate by listening, in great and frequent peril, can distinguish the bearings of each in a dense fog. The threatening speech of Duck Island's ledge, the swing of the wave over Halfway Rock, the touch of the ripples on the beach at Londoner's the long and lazy breaker that is forever rolling below the lighthouse at White Island—all are familiar and distinct, and indicate to the islander his whereabouts almost as clearly as if they shone brightly and no shrouding mist were striving to mock and to mislead him.

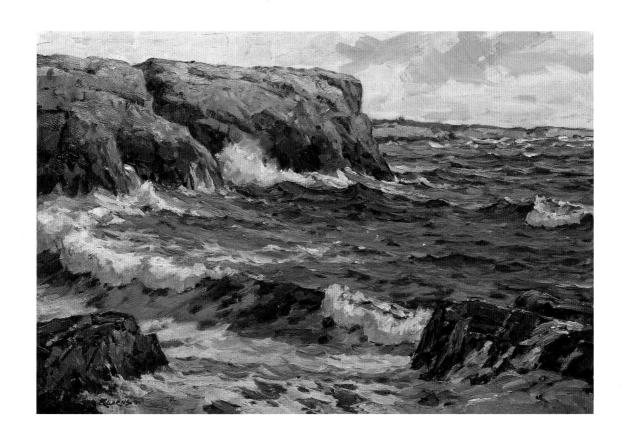

Stapleton Kearns, *Surf at Star Island*, oil on canvas, 16 x 24 in.

47 Sean Beavers, *Over Looking Eastern Rocks*, oil on canvas laid on panel, 20 x 20 in.

21 Olaf Martinius Brauner (1869–1947), *Sailing off the Isles of Shoals*, oil on canvas, 8 x 6 in.

 6 Ron Brown, *White Island Light*, oil on canvas, 24 x 30 in.

18 John Appleton Brown (1844–1902), *Appeldore*, oil on canvas, 16 x 28 in.

10 T. A. Charron, *White Island Light*, oil on panel, 16 x 20 in.

59 Tom Chase, *Knitting at the Isles of Shoals*, oil on linen, 24 x 32 in.

67 William R. Davis, *Dusk at Isles of Shoals*, oil on panel, 8 x 12 in.

37 Katherine Doyle, *Islands*, mixed media on paper, 26 x 20 in.

19 Samuel Lancaster Gerry (1813–1891), *Celia Thaxter's Cows*, watercolor, 7 ½ x 12 ½ in.

31 Tom Glover, Sea Mist, oil on panel, 14 x 18 in.

43 Mike Graves, *White Island Light*, oil on linen, 16 x 20 in.

33 Louis Guarnaccia, *Breaking Light*, oil on linen, 8 x 10 in.

69 Grant Hacking, *Snowy Owl, Isles of Shoals*, oil on canvas, 30 x 40 in.

51 John Philip Hagen, *Star Island*, oil on canvas, 9 x 12 in.

61 Simon Harling, *Evening Light from Fort Stark*, oil on canvas, 24 x 48 in.

15 William Frederick De Haas (1830–1880), *From Appledore Island*, oil on board, 8 x 14 in.

 9 Childe Hassam (1859–1935), *Appledore Sunrise*, oil on cigar box lid, 5 ½ x 8 ⅜ in.

22 John Woodsum Hatch (1920–1998), *Jumping off Rock*, acrylic and egg tempera on panel, 36 x 48 in.

71 Stapleton Kearns, *Surf at Star Island*, oil on canvas, 16 x 24 in.

29 Sally Ladd-Cole, *View from Wallace Sands*, oil on canvas, 30 x 40 in.

53 Jamie LaFleur, *Sunrise at Smuttynose*, oil on canvas, 11 x 14 in.

24 Herbert S. Lourie (1923–1981), *Malaga and Smuttynose,* watercolor, 15 ⅛ x 20 ⅝ in.

45 James Laurier, *Across Gosport Harbor*, oil on canvas, 8 x 10 in.

23 Edmond Darch Lewis (1835–1910), *Along the Coast,* watercolor, 9 ¼ x 19 ¾ in.

35 Barrett McDevitt, *Rocks on Star Island*, oil on canvas laid on board, 12 x 16 in.

25 John Christopher Miles (1837–1911), *Moon Rise at the Isles of Shoals,* oil on canvas, 15 x 30 in.

 5 Addison Thomas Millar (1860–1913), *Portsmouth*, oil on board, 14 x 9 ¾ in.

41 Lisa Jelleme-Miller, *Stone Cottages, Star Island*, oil on board, 18 x 24 in.

 1 Scott Moore, *Out to Sea*, oil on linen, 24 x 48 in.

49 Scott Moore, *White Island Light from Star Island*, oil on linen, 18 x 36 in.

63 John Morrison, *Appledore Island,* oil on linen, 12 x 18 in.

55 Dennis Perrin, *At the point*, oil on linen, 36 x 24 in.

39 Catherine Raynes, *Star Island Barn*, oil on panel, 11 x 14 in.

17 Warren W. Sheppard (1858–1937), *Off the Coast*, watercolor, 9 ½ x 13 ½ in.

27 Warren W. Sheppard (1858–1937), *Sailing by Moonlight*, oil on canvas, 12 x 10 in.

65 Sydney Sparrow, *Appledore's Dusk*, oil on canvas laid on panel, 16 x 24 in.

57 Dahl Taylor, *Star Island*, acrylic on canvas, 16 x 20 in.

16 Charles Herbert Woodbury (1864–1940), *Color Note*, oil on board, 8 x 10 in.